POCKET GUIDES

MYTHS AN[D

Mari

NATIONAL GALLERY COMPANY LONDON

DISTRIBUTED BY YALE UNIVERSITY PRESS

THE POCKET GUIDE SERIES

Allegory, Erika Langmuir

Angels, Erika Langmuir

Colour, David Bomford and Ashok Roy

Conservation of Paintings, David Bomford

Faces, Alexander Sturgis

Flowers and Fruit, Celia Fisher

Frames, Nicholas Penny

Impressionism, Kathleen Adler

Landscape, Erika Langmuir

Narrative, Erika Langmuir

Saints, Erika Langmuir

Still Life, Erika Langmuir

Front cover and page 5: Sandro Botticelli, *Venus and Mars*, about 1485, details.
Title page: Lucas Cranach the Elder, *Cupid complaining to Venus*, about 1525, detail.

All measurements give height before width, and depth where necessary.

First published in Great Britain in 2005 by
National Gallery Company Limited
St Vincent House, 30 Orange Street, London WC2H 7HH
www.nationalgallery.co.uk

ISBN 1 85709 391 7

525240

British Library Cataloguing-in-Publication Data
A catalogue record is available from the British Library
Library of Congress Catalog Card Number 2003105497

Edited by Claire Young
Designed by Gillian Greenwood
Production by Jane Hyne and Penny Le Tissier

Printed and bound by Printing Express, Hong Kong

CONTENTS

FOREWORD

The National Gallery has one of the greatest collections of European paintings in the world. It is open every day free of charge and is visited each year by millions of people.

We hang the collection by date, to allow those visitors an experience which is virtually unique: they can walk through a history of Western painting as it developed across the whole of the Renaissance to the end of the nineteenth century – from Giotto to Cézanne.

But if that is a story only the National Gallery can tell effectively, it is by no means the only story. The purpose of this series of *Pocket Guides* is to explore some of the others: to re-hang the collection according to subject, rather than date; to allow you to take it home in a number of different shapes, and to follow different themes.

Mythological subjects inspire some of the most popular works in the National Gallery collection. The fantastical lands and exotic creatures – and the stories they capture – are invariably action-packed, spectacular and sensual. Mari Griffith reminds us of the literary sources for these works, and why patrons commissioned them throughout the centuries.

These are the kind of subjects that the *Pocket Guides* address. The pleasures of pictures are inexhaustible. Our hope is that these little books will point their readers towards new ones, prompt them to come to the Gallery again and again, and accompany them on further voyages of discovery.

Charles Saumarez Smith
DIRECTOR

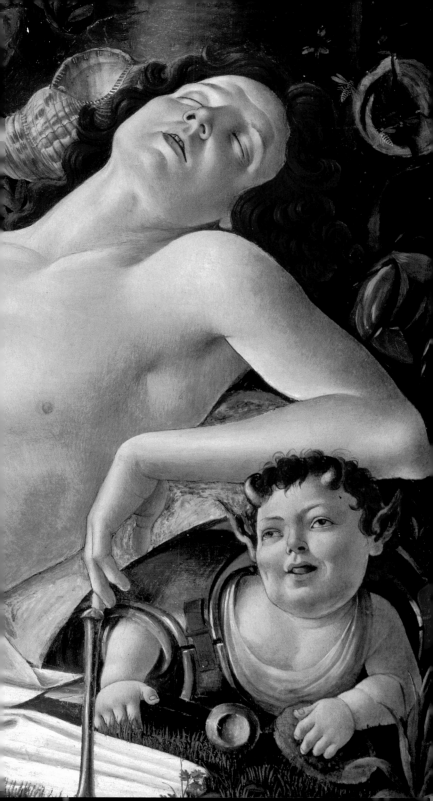

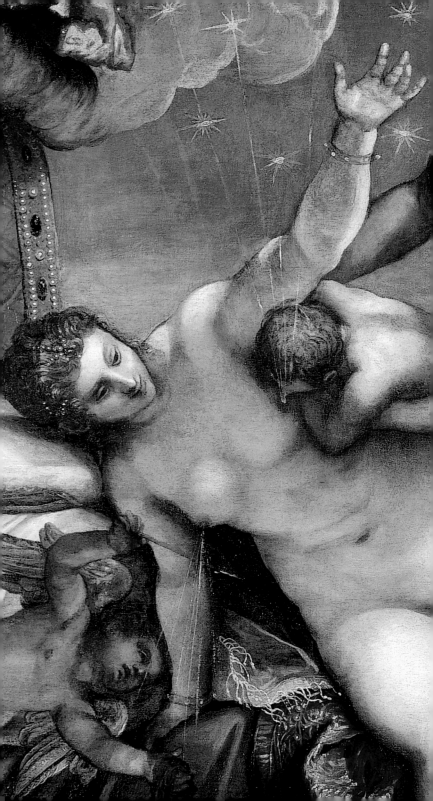

INTRODUCTION

As you walk through the National Gallery, or any Old Master collection, you soon find yourself face-to-face with the gods and heroes of classical mythology: naked or semi-naked figures performing heroic feats or indulging in amorous escapades. For centuries, the myths of ancient Greece and Rome were some of the principal subjects of European art. With their themes of love and loss, trial and reward, adventure and transformation, these stories gave artists sensational material. They also held a strong appeal for patrons, whose desire for pictures of the gods and goddesses of antiquity was a powerful incentive for artists from the fifteenth century onwards.

But what do these mythological characters mean to us today? On the one hand, our culture is steeped in their legacy. Their names pepper our vocabulary: 'Saturday' gains its name from Saturn, and 'January' from Janus, the god of doors or openings; we speak of a 'Herculean' effort, and of a vain person as 'narcissistic'. Also, the plots of the ancient myths live on in our modern-day fairy tales, literature and films. In fact, the gods are around us everywhere: chubby cupids adorn Valentine's cards; Mercury, the messenger of the gods, serves as the logo for Interflora; and Apollo, god of the sun, gave his name to a famous US space mission.

Despite these continuities, when it comes to looking at mythological paintings, the language and symbols of the artists of the past are often beyond us. The purpose of this *Pocket Guide* is to give you some guidance to interpreting their works and it can either be read as a continuous narrative or to look up individual characters or paintings. Starting with a brief overview of the development and functions of mythological paintings, it goes on to take a more detailed look at some of the characters and creatures depicted, among them gods, goddesses, heroes, nymphs and monsters.

1. Detail of *The Origin of the Milky Way*, Jacopo Tintoretto, 29.

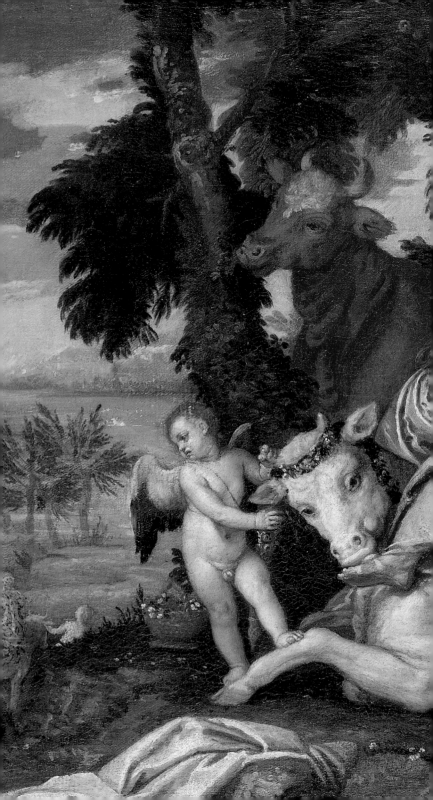

MYTHS
AND LEGENDS

Ever since ancient Greece, people have tried to define the meaning of myths and legends. The words themselves offer little insight: 'myth' comes from the Greek *mythos*, which originally meant 'word' or 'story', while 'legend' derives from the Latin *legenda*, which means to be read. The simplest and baldest definition would be that myths and legends are traditional stories with no known author, passed down from one generation to the next, and adapted to suit each age. While legends tend to parade as accounts of real historical events or people, like King Arthur or the Christian saints, myths describe a very different realm.

In the Greek mythological world, the gods are immortal and have the power to transport themselves magically from place to place. At the same time they look and behave like humans, and their lives closely intersect with those of mortals, not least in love affairs. The children produced from these unions – demi-gods like Perseus – become the heroes and leaders of the Greek people. This intimate connection between gods and mortals is echoed in the close relationship between humans and animals, which derives from a time immemorial when the divisions between gods, mortals and beasts were far less clearly defined. The Greek myths are peopled by strange hybrid creatures: like the half-human and half-equine centaurs, which represent the baser side of man's nature; and the half-human and half-goat satyrs, the spirits of the woods and mountains. Their female counterparts, the nymphs, were also closely associated with nature, and inhabited the seas, rivers, pools and hills.

For the ancient Greeks and Romans, these creatures were far more than just fictional characters and the myths were more than just stories. In the classical world – ranging from around the fifth century BC in ancient Greece to the later Roman Empire – the mythological gods and goddesses were still actively worshipped, and the myths themselves played an important part in religious rituals. Not only were they recited in public on certain dates of the religious

2. Detail of *The Rape of Europa*, Paolo Veronese, 44.

9

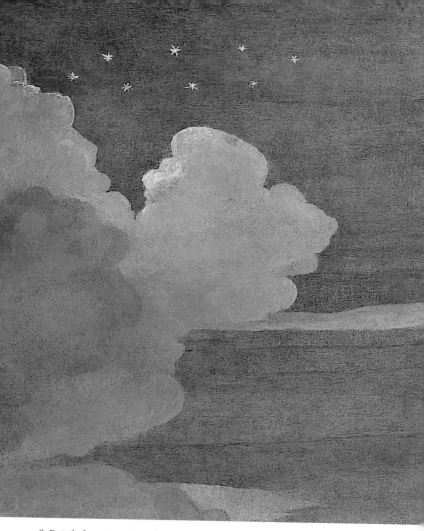

3. Detail of *Bacchus and Ariadne*, Titian, 10.

calendar, they also held the key to some of life's most fundamental questions: how the world began; how nature took shape; how the gods came to be; how they influenced the lives of mortals.

Later, when the Greek pantheon was adopted in Rome, although Gods' identities remained largely the same, their names changed. Zeus became known as Jupiter, Poseidon as Neptune, Hades as Pluto, and so on. In this book, we have used the Latin names, as artists tended to refer to Latin sources, at least until the eighteenth century. If you want to compare the Greek and Latin names you will find a glossary at the end of the book.

SURVIVAL
OF THE GODS

By the later years of the Roman Empire, as Christianity became widespread, the ancient gods lost their primacy. In the fourth century, just 80 years after Christianity became the official religion of the Roman Empire, Emperor Theodosius (about AD 346–395) banned people from worshipping the older pagan deities. Yet over the centuries that followed they never entirely disappeared. Taking on different forms and meanings, they continued to exert their influence through to the Middle Ages and beyond.

Theology was one area in which the gods survived. The early church fathers were familiar with the ancient texts, and although they recognised the existence of the pagan gods, they argued that they had been real men and women – rulers or leaders – who were deified after their death. This was not a new idea; the Greek mythographer Euhemerus had first made this claim back in the fourth century BC, but for the early Christians, this was a way of diminishing the supernatural aura of the antique gods. Ironically though, it was one of the factors that ensured their survival. By the Middle Ages people started research-ing the genealogy of the gods, as if they were real people, and in some cases, they even began claiming descent from them. Venus' son Aeneas, for example, came to be seen as the legendary founder of Rome, and thus the ancestor of all Romans.

The gods also lived on in the field of astrology. The planets and stars go by the names of the ancient deities, just as they have done since pre-classical times. During the reign of Emperor Augustus (63 BC–AD 14) the names of the planets were also applied to the days of the week. In any Latin-based language, this tradition is evident; Tuesday, the day of Mars, is still '*mardi*' in French, '*martes*' in Spanish, and '*martedi*' in Italian. Beyond just the names how-ever, the ancients also believed that the heavenly bodies were like gods themselves, and could deter-mine people's fates. This idea derived from eastern religions, and became widespread in the late antique period when a whole system of thought was built

around astrology. It was used to explain all kinds of phenomena, from the seasons and elements to the humours – a person's temperament or mental disposition. The study of astrology was entrenched in so many areas that it ensured the continuing influence of the gods.

The pagan deities also survived in the work of medieval scholars who continued to read the ancient myths, but rarely took them at face value. Instead, they understood these tales as allegories that could be interpreted to reveal Christian truths. In this tradition, Daphne, who rejected Apollo's amorous advances, was regarded as a paragon of virginity, and therefore a precursor of the Virgin Mary. Likewise, the rape of Europa by Jupiter (disguised as a bull) was thought to symbolise the union of God (Jupiter) and the soul (Europa). Read in this way, stories that might otherwise have seemed salacious or violent were given more spiritually elevated meanings. The most famous work of this kind was a fourteenth-century French poem called the *Ovide Moralisé*, and this same approach continued well into the fifteenth century. For example, some scholars regarded the beauty of Venus as a manifestation of the divine, an idea that filters through in the paintings of Sandro Botticelli, many of which were made for the Florentine leader and classical enthusiast Lorenzo de' Medici.

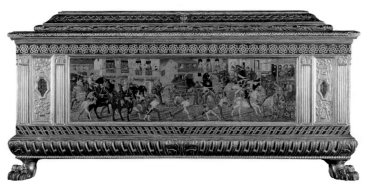

4. Italian, Florentine, *Cassone with a Tournament Scene*, probably about 1455–65, 38.1 × 130.2 cm.

MYTHS AND MORALS

This way of understanding ancient myths – as stories that contain hidden moral truths – lies at the heart of some of the National Gallery's earliest mythological paintings. These date from the fifteenth century, and were largely made to adorn furniture or other small-scale objects for the home. At that time, it was the custom, particularly in Florence, for newly wed couples to acquire painted chests – *cassoni* – or headboards at the time of their marriage [4]. Destined for the new marital homes, their surfaces were often painted with scenes either from classical mythology or ancient history – subjects that, as well as being decorative and entertaining, also conveyed a moral message.

A Satyr mourning over a Nymph [5] by Piero di Cosimo is one such painting. Its rectangular shape tells us that it was probably intended as a *spalliera* painting, a panel displayed at shoulder height or adorning furniture (from the Italian word for shoulder, *spalla*). It depicts the tragic story of Procris. Convinced her husband Cephalus was being unfaithful she followed him out hunting. On hearing a rustle in the

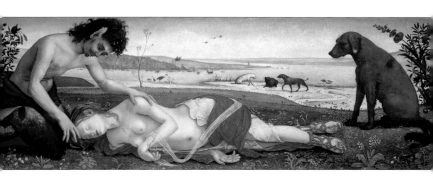

bushes, Cephalus mistook Procris for a wild animal, and killed her with his spear. This tale would have offered Florentine wives a very clear warning of the terrible consequences of doubting their husbands' fidelity. *Venus and Mars* by Sandro Botticelli [6], which is also rectangular in shape, was made for a

5. Piero di Cosimo, *A Satyr mourning over a Nymph*, about 1495, 65.4 × 184.2 cm.

13

similar purpose, but the painting that adorns it conveys a more positive message. It is an allegory because although Mars and Venus are the most famous of mythological lovers, there is no story known that fits this scene: Mars, the god of war, has been left exhausted by their lovemaking, and while he rests, a group of playful fauns make off with his lance and armour. Naked and asleep, he is entirely vulnerable, while Venus retains both her clothes and her composure. The message is that love is stronger than war, and it is conveyed with a delightful sense of humour and sophistication.

The Abduction of Helen attributed to Zanobi Strozzi [7] was also made for a private, domestic setting, but its octagonal shape suggests that it may have been a birth tray (*desco da parto*). This was a type of commemorative object, popular in fifteenth-century Tuscany, made to celebrate the birth of a new child. It depicts the episode that sparked off the Trojan War: the Trojan prince and shepherd Paris carries off the beautiful Helen whom Venus had promised to Paris as his wife. However Helen was already married to the king of Sparta and the Greeks followed in rapid pursuit, leading to the ten-year Trojan War. This tale of adultery, abduction and war gave fifteenth-century viewers a cautionary message about the dangers of infidelity.

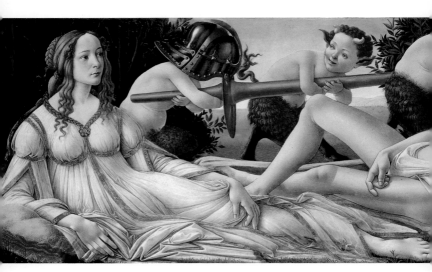

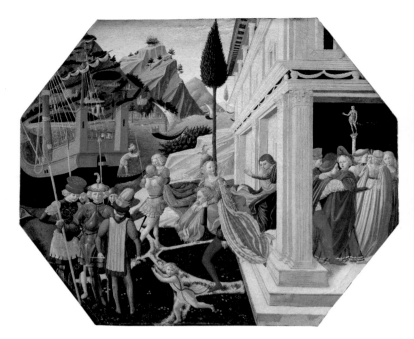

Strozzi's painting presents us with a very interesting combination of old and new. On the one hand, its choice of subject is entirely up-to-date, and reflects the fifteenth-century's growing interest in the ancient world. On the other hand, the way Strozzi depicted this scene, with the characters wearing the fashions of his own day, looks back to the conventions of medieval art. Treating the myth in this way made the story more

7. Attributed to Zanobi Strozzi, *The Abduction of Helen*, about 1450–5, 51 × 60.8 cm.

immediate and believable for the artist's contemporaries, but the real reason behind it was that people at this time had little idea of what the ancient world actually looked like. However, Italy was just entering a new cultural epoch – the Renaissance, a revival and rediscovery of classical subjects and style in art and literature, which transformed the way artists depicted the world and everything in it, not least the Greek myths.

15

THE LOST
CLASSICAL SPIRIT

The term Renaissance literally means 'rebirth', and refers to a rediscovery of antique culture in the fifteenth century. This extended to all areas: forgotten texts were translated, architectural principles were revived, buried treasures were unearthed, and classical myths and history appeared as the subjects of paintings. As the century progressed, artists also began to address these ancient subjects in a style that was more classical in spirit. To do this, they emulated antique sculptures, copying the costumes, body types, and even the poses they saw in them. Portraits of the early Renaissance, for example, often show their sitters in profile, like the coins and medals of antiquity. Later, the sculpture of *Laocoön and his Sons* [9], which was discovered in Rome in 1506, provided inspiration for countless artists. This desire to capture the spirit and atmosphere of the lost ancient world – known as painting *all'antica*, or in an antique manner – was one of the main characteristics that differentiated Renaissance and Medieval art.

One artist who was determined to recreate the spirit of the classical world with archaeological accuracy was Andrea Mantegna. His painting *The Introduction of the Cult of Cybele at Rome* [8] shows just how care-

8. Andrea Mantegna, *The Introduction of the Cult of Cybele at Rome*, 1505–6, 73.7 × 268 cm.

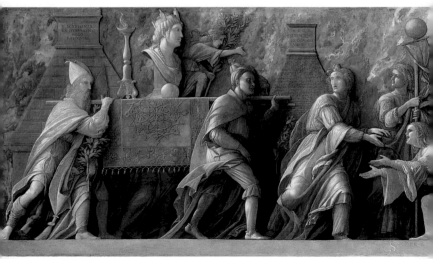

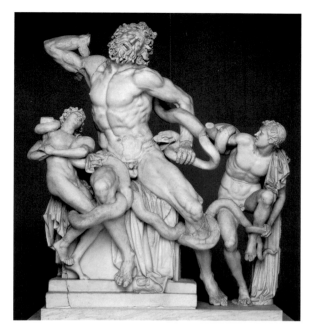

fully he undertook this endeavour. At first sight, this painted canvas might easily be mistaken for an antique relief sculpture: it has the same long rectangular shape, a similar composition and costumes, and appears to be made of stone. In creating this *trompe l'oeil* effect, Mantegna was following a classical precedent: the story of a Greek painter called Zeuxis, recounted by the Roman writer Pliny the Younger

9. *Laocoön and his Sons*, first century AD, marble, height 242 cm. Museo Pio-Clementino Vatican Museums, Vatican City (1059).

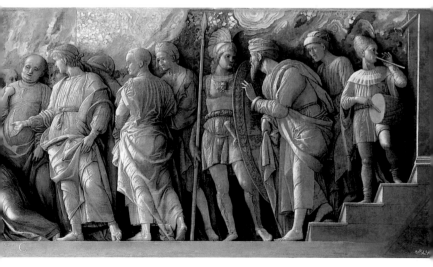

17

(AD 61–113). Zeuxis was famed for painting grapes in such a lifelike way that birds would fly down from the sky to peck at them. Likewise Mantegna led the viewer to believe that this canvas was indeed marble, and in doing so, showed that he too possessed the skill most admired in artists of the ancient world: that magical ability to fool the eye.

During the fifteenth century, no paintings were known to have survived from the classical world, but artists had at their disposal ancient descriptions of lost works of art. Known as *ekphrasis*, this literary form was practised by the leading writers and poets of ancient Rome, among them Pliny the Younger and Catullus (about 84–54 BC). Renaissance patrons, perhaps wanting to own their own 'classical' painting, commissioned recreations of these paintings (which may never have existed). This presented an immense challenge for artists; not only did they have to transform a long list of details into a coherent visual image, they also had to conjure up the appearance and atmosphere of the ancient world.

One of the most spectacular examples of this kind of painting is *Bacchus and Ariadne* [10] by the great Venetian painter, Titian. At its centre, Bacchus, god of wine, leaps towards Ariadne, who has been abandoned on the shores of Naxos by her lover Theseus. As she reaches disconsolately towards Theseus' departing ship, Bacchus comes to her rescue: their eyes meet, and they fall in love. This subject comes from a poem by Catullus, which describes an elaborate bedcover that had pictures embroidered on it: Ariadne in one part, and Bacchus with his wild and noisy entourage in another. Titian combined these two vignettes and enlivened them with other details from the poem, like the satyrs waving animal limbs in the air and maenads shaking tambourines and clashing cymbals. For a description of the encounter between Bacchus and Ariadne, Titian turned to the *Ars Amatoria* by the Roman poet, Ovid (about 43 BC–AD 18). This poem describes how Bacchus, on seeing Ariadne, bounded from his chariot onto the sandy ground, and took her in his arms, promising her the stars as a token of his love.

Like most artists of this period, Titian was not educated in Greek and Latin, and working on an elaborate scheme like this one, he would have been

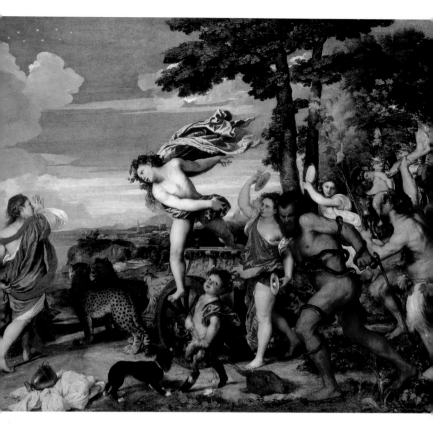

advised by a scholar who was also employed by the patron. However, Titian did far more than just illustrate existing texts; he wove the details together into a compelling narrative, and infused them with dramatic and emotional punch. For this, he could rely solely on his own ingenuity and imagination.

Bacchus and Ariadne is much grander in scale and ambition than the *cassone* and *spalliera* paintings we started with, but it too was also made for a private, domestic setting: the *studiolo* of Alfonso d'Este (1476–1534), duke of Ferrara [12]. The *studiolo* was an important feature of an Italian Renaissance palace. It was a small room filled with paintings, sculptures, rarities and manuscripts, where the educated elite showed off and indulged in their intellectual interests. In his *studiolo*, Alfonso d'Este recreated an ancient gallery of pictures that was described by the first-century writer Philostratus (about AD 170–249). The duke spared no expense, commissioning paintings

10. Titian, *Bacchus and Ariadne*, 1520–3, 176.5 × 191 cm.

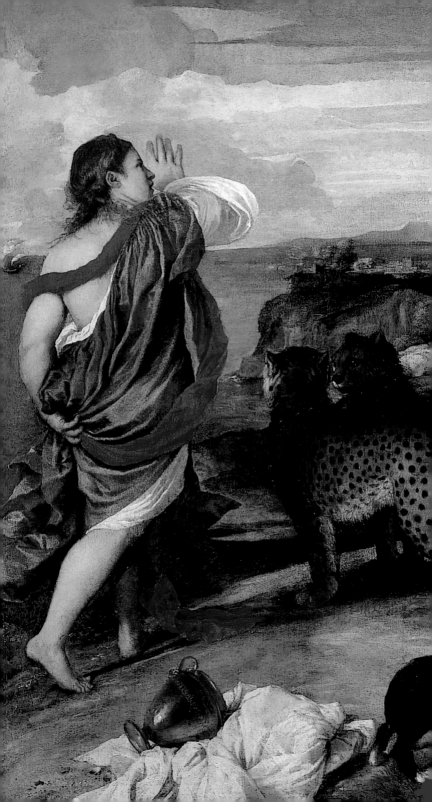

from the best artists of his day, and in the final scheme, works by Titian hung alongside paintings by Giovanni Bellini and Dosso Dossi. With paintings hung all around it in emulation of an ancient art gallery, this magnificent room was a place where a chosen few could share with like-minded people their knowledge and enjoyment of the classical realm. It was an opportunity to step back into the lost world of antiquity.

11. Detail of 10.

DOOR

Bacchus and Ariadne

The Andrians

WINDOW

The Feast of the Gods

WINDOW

Bacchanal with Vulcan

The Worship of Venus

DOOR

12. Reconstruction of Alfonso d'Este's *studiolo*, showing location of pictures, including *Bachus and Ariadne*.

THE USES OF MYTHS

For an erudite patron like Alfonso d'Este, mytho-
logical paintings were a source of aesthetic and
intellectual enjoyment, but for others, mythology
offered a very different kind of pleasure. Pictures of
goddesses and nymphs gave artists the perfect oppor-
tunity to paint the female nude, which from the early
sixteenth century onwards became an increasingly
popular genre of painting. At this time, nudes were
almost always presented in the guise of a mythologi-
cal character, giving this otherwise risqué subject the
veneer of respectability.

In *Cupid complaining to Venus* [14] by the German
artist Lucas Cranach the Elder, Venus is an extremely
contradictory figure. She looks at us seductively,
wearing nothing but a fashionable hat and necklace,
which make her look more like a sixteenth-century
pin-up than a classical goddess. But she also
presents us with a moral warning: notice how she
proffers the branch of an apple tree, like the Biblical
temptress Eve, which reminds us that temptation is
followed by a fall. This message is emphasised by
Cupid who, having been tempted to steal a sweet
honeycomb, has been stung by bees. Cranach took
this subject from a poem by the third-century BC
Greek poet Theocritus, an excerpt of which he
included in the top right-hand corner [13]. It stresses
that pleasure goes hand-in-hand with pain. In
Protestant Germany this moral warning would per-
haps have justified the painting's otherwise blatant
sensuality.

13. Detail of 14.

22

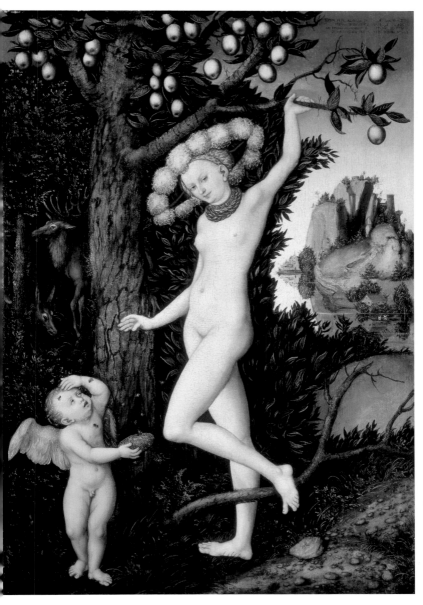

Although Cranach was depicting a mythological subject, he did not paint it in a classical or *all'antica* style. Venus' slim, high-waisted figure conforms more to medieval than classical precedents, and she stands in a distinctively Northern European setting, with its dark forest and cliff-top castle. The Renaissance, which spread through Italy in the fourteenth and

14. Lucas Cranach the Elder, *Cupid complaining to Venus*, about 1525, 81.3 × 54.6 cm.

fifteenth centuries, was slower to reach Northern Europe, when in the early sixteenth century, the German artist Albrecht Dürer became interested in the principles of the Italian Renaissance, and made drawings and prints showing the human figure with classical proportions.

Mythological nudes like Cranach's were intended as private paintings, and were often concealed behind curtains. This genre continued to be popular in the seventeenth century. In Northern Europe, it became a favourite theme of the Flemish artist Peter Paul Rubens, but in Spain, artists were prohibited from painting the naked human body. However, the National Gallery owns a rare nude by the great Spanish master Diego Velázquez [15]. As court painter to King Philip IV, Velázquez enjoyed more freedom than most Spanish artists of his day, and had access to the magnificent royal collection, which included several mythological paintings by Titian. While these gave Velázquez his model, he broke new ground with this painting, depicting Venus with astonishing realism. Lying on a crumpled bed in what could be a seventeenth-century boudoir, with her hair piled up on the top of her head and her skin luminous, she could almost be mistaken for a real, contemporary woman. The one touch that keeps her within the safe bounds of mythology is the winged child propping up her mirror: Venus' son Cupid.

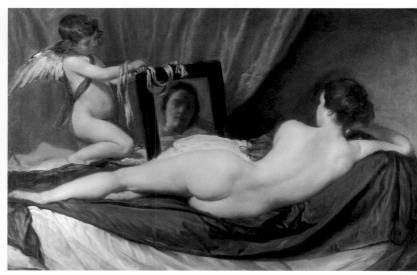

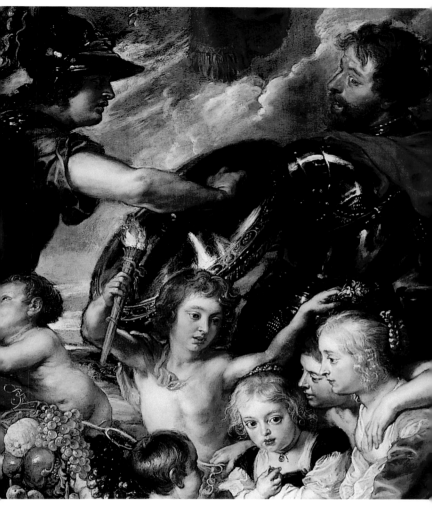

As well as giving artists an opportunity to paint nudes, classical mythology also provided them with a whole set of signs and symbols which they used to convey often complex and sophisticated meanings. An example of this is Rubens's *Minerva protects Pax from Mars ('Peace and War')* [17], which conveys a very specific political agenda. Rubens was not only an artist, but a diplomat acting as an ambassador for the Regent of the Spanish Netherlands, the Archduchess Isabella. In 1630, he travelled to the court of King Charles I in London to try to secure peace between England and Spain. He gave the king this painting, which conveyed his mission more forcefully

POLITICAL AGENDAS

16. Detail of 17.

and eloquently than any diplomat's words could ever have done. Rubens was a highly educated man, very familiar with classical texts, and in this work, he combined a range of allegorical figures and mythological characters in order to communicate his message.

At the centre Minerva, goddess of strength and wisdom [16], pushes away the threatening figure of Mars, god of war. In his absence, Peace is able to nurture the god of wealth, Plutus, allowing good fortune to flourish: prosperity, represented by the

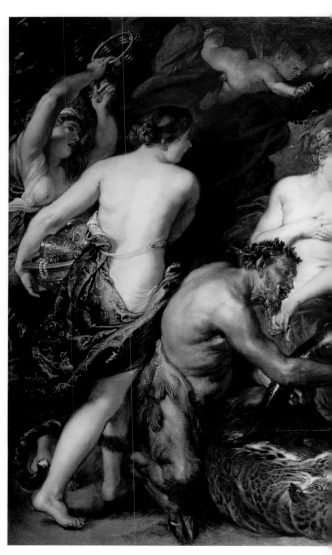

17. Peter Paul Rubens, *Minerva protects Pax from Mars ('Peace and War')*, 1629–30, 203.5 × 298 cm.

basin of gold on the far left; abundance, symbolised by the overflowing cornucopia at the centre; and a peaceful environment for children. On the right, Hymen, the young god of marriage, holds a wreath over the heads of two young girls. Even the leopard and satyr at the front, both tamed, suggest the civilising influence of a peaceful society. This painting shows how, in the seventeenth century, mythological paintings extended beyond the private pleasures of nudes to encompass broader public and political agendas.

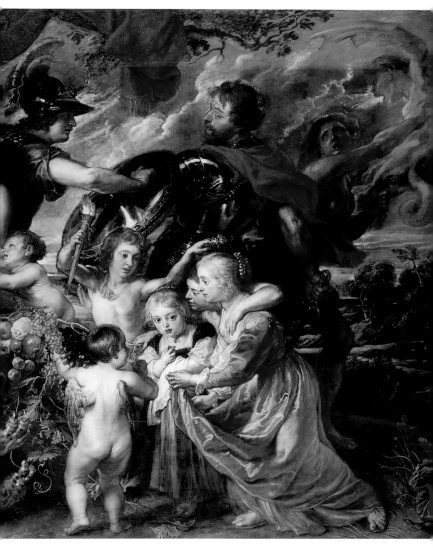

Portrait painters, too, employed mythological characters to enhance their sitters' public image. To be portrayed in the guise of a god or goddess showed the sitter was educated in classical culture, and the choice of character could also emphasise certain qualities or strengths. Just as politicians today wear clothes that convey an image of strength and authority, so in allegorical portraits of the past a leader might have chosen to be portrayed as the valiant Hercules.

18. Pierre Mignard,
*The Marquise de
Seignelay and Two
of her Sons*, 1691,
194.5 × 154.4 cm.

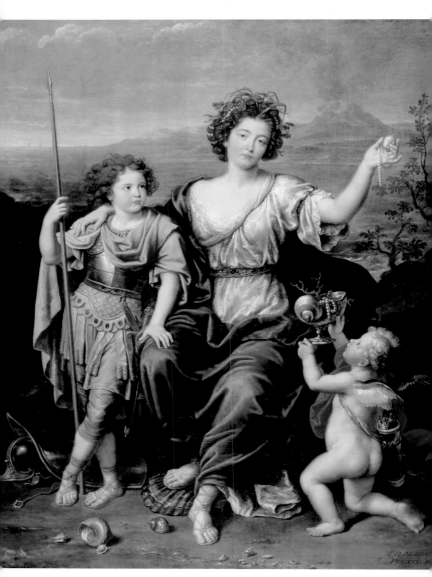

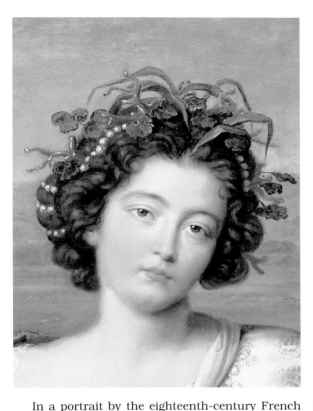

In a portrait by the eighteenth-century French artist Pierre Mignard, his aristocratic sitter, the Marquise de Seignelay, chose to be shown as the sea nymph, Thetis [18]. Crowned with a garland of coral, pearls and seaweed, she sits on the seashore surrounded by exotic shells. This connection with the sea was entirely appropriate because the marquise's deceased husband had been minister for the navy. But the connection between the sitter and her chosen character ran deeper; the marquise no doubt identified with Thetis, who was raped by her suitor Peleus, because she herself had been forced to marry against her will. The parallels do not end there; Thetis had a son called Achilles for whom she had great ambitions. As well as giving him superhuman strength by dipping him into the river Styx, she also procured special armour for him made by Vulcan, the blacksmith of the gods. Similarly, the marquise harboured ambitions for her family; shortly before this portrait was made, she had successfully acquired a military commission for her eldest son, portrayed here as Achilles.

SOURCES FOR
MYTHS

The first written records of Greek myths are two epic poems, the *Iliad* and the *Odyssey*, which date from the eighth century BC, and are believed to be by the Greek poet Homer. The *Iliad* describes a few days of the last year of the Trojan War, and the *Odyssey* is an account of the Greek warrior Ulysses' ten-year journey home from Troy, which was filled with countless adventures and trials. Homer did not invent these stories; archaeological excavations in the late nineteenth century revealed that the Trojan War may actually have happened, and that Troy was a city on the north coast of modern-day Turkey. Whether or not they are based on historical fact, these stories certainly existed before Homer's day, but like any storyteller, he gave them his own individual rendition. The Homeric poems came to play an important part in the religious festivals of ancient Greece: they would be recited in public, for example, at Athens' great four-yearly festival, the Panathenaea. In ancient Rome too, the Trojan War continued to inspire poets. The *Aeneid* by the Roman poet Virgil (70–19 BC) describes the adventures of the Trojan hero Aeneas, who escaped from the burning city and went on to found Rome.

Although the subjects of the *Iliad*, *Odyssey* and *Aeneid* inspired many paintings, the text that perhaps exerted most influence on artists from the Renaissance onwards was the work of the Roman poet Ovid (born AD 43). His *Metamorphoses* was so popular it came to be known as 'The Painter's Bible'. Like Homer's poems, *Metamorphoses* is a compilation of earlier myths, which Ovid retells in a lively, witty and compelling style – they are stories about magical transformations in which living beings are turned into trees, flowers, animals or rivers, and tales about the loves and adventures of the gods. By Ovid's day these myths were regarded less as sacred tales than as entertaining and delightful works of literature.

Another classical author who also inspired artists was Ovid's contemporary, Pliny the Elder (AD 23–79). His most influential work was the *Natural History*, a

20. Detail of
*Landscape with
Aeneas at Delos*,
Claude, 50.

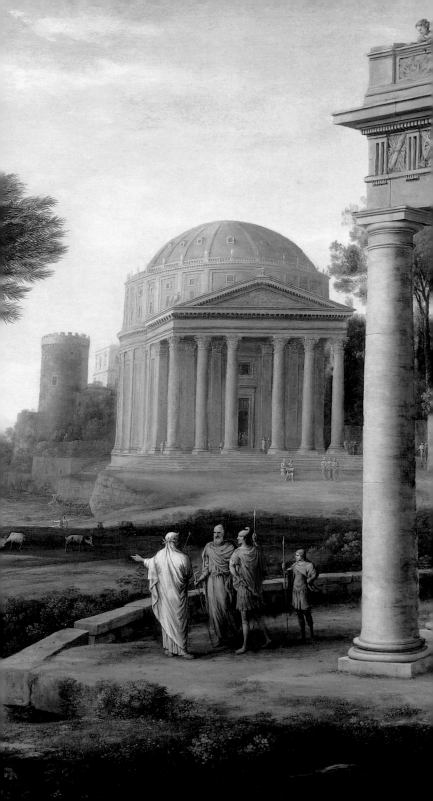

vast encyclopaedia that covered a range of subjects, from geography to zoology, botany, medicine and agriculture. It also included descriptions of antique paintings and sculptures, which artists drew on to try to recreate the lost works of art of the ancient world.

During the Middle Ages and Renaissance, as artists rarely knew Latin or Greek, they often turned to later re-workings of ancient legends, like romances or plays, which were written in their own language. For his painting of *A Satyr mourning over a Nymph* [21], for example, Piero di Cosimo did not use Ovid's *Metamorphoses*, the original source for the story of Cephalus and Procris but a later play written by the Ferrarese court poet, Niccolò da Correggio. We know this because the satyr, who mourns the dead Procris in the painting, plays a more important part in the play than he does in the myth.

21. Detail of 5.

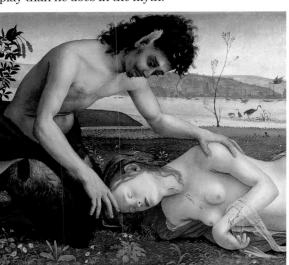

While these literary sources provided the subjects, sixteenth-century artists' handbooks offered specific guidelines on how the gods should look, and what their attributes should be. The most influential of these was *The Image of the Ancient Gods* by Vincenzo Cartari, first published in Venice in the mid-1550s. Later editions of the book included illustrations, and were translated into a number of different languages, which ensured that its influence spread across Europe.

MYTHOLOGICAL CHARACTERS

The following characters can all be found in mythological paintings at the National Gallery. For ease of reference, they are divided here into different types: gods and goddesses; nymphs and maidens; heroes, princes and demi-gods; and lastly, hybrids and monsters.

APOLLO, god of the sun, is often painted as a beautiful young man with a halo of light around his head. He was the son of Jupiter and Latona, and the twin brother of the huntress Diana. Apollo was also patron of the Arts, and leader of the Muses, the goddesses of creative and intellectual inspiration. He often holds a lyre and wears a crown of laurel leaves, attributes of his skill in poetry and music. *The Judgement of Midas* by the seventeenth-century Bolognese artist Domenichino [22] depicts a musical contest that took place between Apollo and the satyr Pan. The judge, King Midas, chose Pan as the winner,

GODS AND GODDESSES

22. Domenichino and Assistants, *The Judgement of Midas*, 1616–18, 267 × 224 cm, detail.

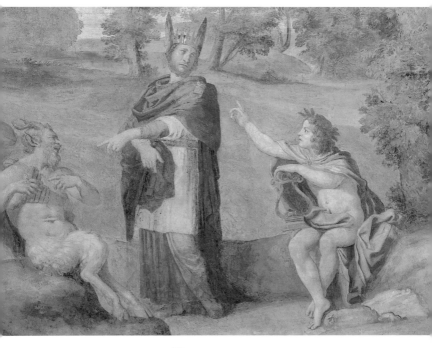

and Apollo was so outraged, he took revenge on Midas by giving him ass's ears. This painting is one of a series of ten frescoes representing different episodes from Apollo's legend, which Domenichino made for the garden pavilion of Cardinal Pietro Aldobrandini's country retreat in Frascati outside Rome. Built in 1615, it emulated the ancient Roman fashion of decorating this kind of building with landscape views. In the eighteenth century eight frescoes were removed from the walls and attached to canvases, now in the National Gallery.

BACCHUS, the god of wine, is usually portrayed wearing a crown of vine leaves or ivy [23]. *The Nurture of Bacchus* by Nicolas Poussin, shows him as a child, being reared on wine. Bacchus was another of Jupiter's sons. His mother, Semele, died before he was born, so Jupiter took the child from her womb, and sewed him into his thigh from which he was born. In this painting, Bacchus is in the care of his adoptive parents – Semele's sister Ino and her husband Athamas. On the left is one of the satyrs, who always

23. Nicolas Poussin, *The Nurture of Bacchus*, about 1628, 80.9 × 97.7 cm, detail.

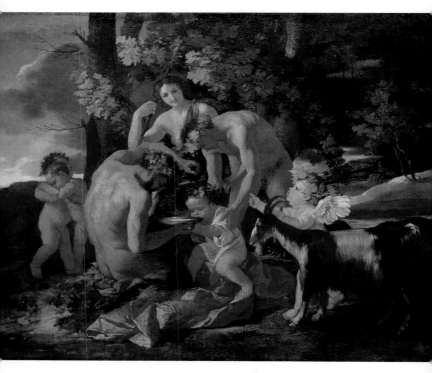

24. Detail of 23.

form part of Bacchus' entourage, usually shown drinking wine, dancing, and enjoying all kinds of revelries. The goats on the right remind us of Bacchus' origins as a fertility god who was worshipped in the form of a goat. Although Poussin was French he spent most of his life in Rome, where he was able to study and copy ancient Roman sculptures. His erudite paintings, which are classical both in subject and style, reflect his profound knowledge of ancient Roman art and culture.

CERES, goddess of agriculture, was the sister of Jupiter, and reigned over the earth's fertility. The myth most associated with Ceres is the abduction of her beloved daughter, Proserpine: while picking flowers in woods, Proserpine was dramatically seized by Pluto, the god of the Underworld, and carried off to

25. Simon Vouet
and Studio,
*Ceres and
Harvesting Cupids*,
probably 1634–5,
145.5 × 188 cm.

26. Detail of 25.

his kingdom. Ceres was distraught when she realised that Proserpine was missing, leaving crops neglected and lands barren as she searched for her lost daughter. According to some interpretations of this myth, she did this deliberately to punish humans and the other gods for their role in Proserpine's disappearance. With the earth desolate, Jupiter had to intervene; he ordered that Proserpine be allowed to return to Ceres for part of the year and that, according to this myth, is the origin of the cycle of the seasons.

Ceres and Harvesting Cupids [25], by the studio of the seventeenth-century French artist Simon Vouet, shows Ceres resting in a golden cornfield, which she has been harvesting with the help of winged infants, or *putti*. She is identified by her crown of corn and is probably intended to personify summer. This painting was likely to have been made for the Hôtel de Bullion, a private house in Paris, along with two other mythological paintings, now lost: one, showing Diana and Actaeon, was on the theme of hunting, and the other, depicting Silenus and satyrs, represented the wine harvest.

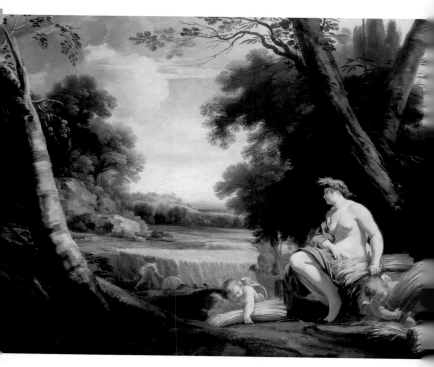

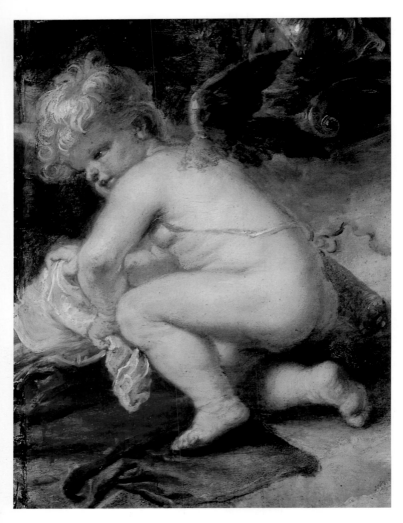

27. Detail of 53. CUPID, god of love, was the mischievous son of Venus, who made both gods and mortals fall in love. He had two sets of arrows: golden arrows that made people fall in love, and lead arrows that made them feel aversion towards each other. Cupid often caused trouble, as in the story of Apollo and Daphne [39], and was punished as a result. From the Middle Ages onwards, he is sometimes shown wearing a blindfold: not only because love, as they say, is blind, but also to symbolise the darkness of sin. Cupid is often included in paintings of Venus, where he serves as her attribute, a role he fulfils in Rubens's *The Judgement of Paris* [27].

DIANA, virgin goddess of hunting, was a paragon of chastity, and fierce in her punishment of anyone who failed to comply with her strict rules. We get a glimpse of her vengeful wrath in Titian's *The Death of Actaeon* [28]. While out hunting in the forest, Actaeon accidentally came upon Diana bathing. Enraged, she splashed him with water, which transformed him into a stag. In this painting, he is shown turning from human to beast, as he is dramatically felled by his hunting dogs, which tear him to pieces. Diana seems indomitable as she strides forward with her bow at the ready, which does not feature in Ovid's tale, but serves here as her attribute. Above Diana, the moonlit sky also identifies her as the goddess of the moon. This late work by Titian was probably made for King Philip II of Spain who, between 1554 and 1562, commissioned a group of large mythological paintings from the artist. Titian referred to these later works as *poesie*, or poetries,

28. Titian, *The Death of Actaeon*, 1565–76, 178.4 × 198.1 cm.

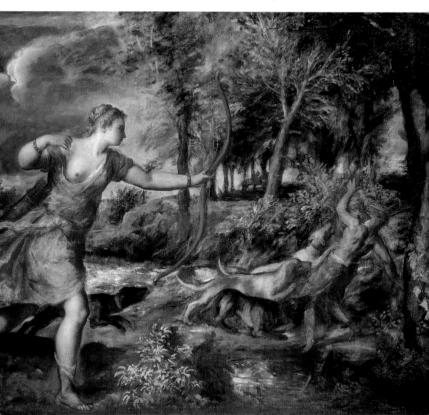

which implies that he regarded them as far more than illustrations of the ancient poems, but as poetic interpretations in their own right. Although *The Death of Actaeon* was mentioned in a letter sent to the king, for reasons unknown, it was never sent to Spain.

JUNO, the queen of the gods, was both the sister and wife of Jupiter. She is usually portrayed watching over her errant husband, and seeking revenge against her many lovers. In paintings, she is identified by her attribute, the peacock. In *The Origin of the Milky Way* [29] by the sixteenth-century Venetian artist Jacopo Tintoretto, her peacocks perch on her airborne bed alongside Jupiter's eagle, which hovers above gripping a thunderbolt in its claws. Jupiter swoops in holding Hercules, his son from a dalliance with a mortal woman called Alcmena and sets the child on Juno's breast, thereby making him immortal. Hercules sucks so hard that the goddess's milk spurts up into the sky, where it turns into

29. Jacopo Tintoretto, *The Origin of the Milky Way*, about 1575, 148 × 165.1 cm.

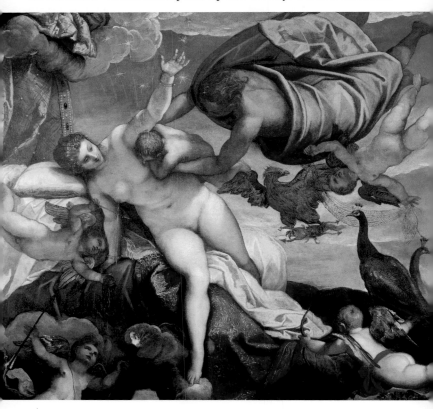

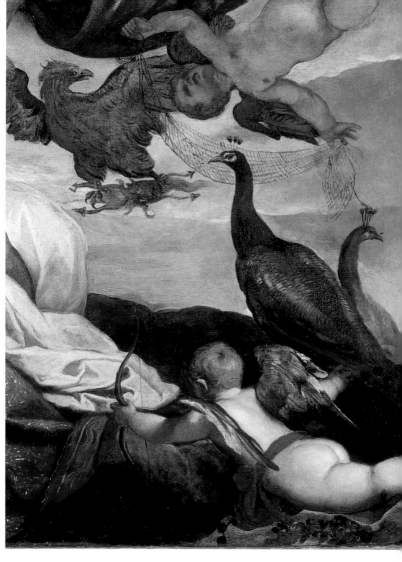

a circle of stars – the Milky Way. It also sprays down to earth, and transforms into white lilies. We know from an early copy of this painting that Tintoretto originally included these too, but the canvas was cut down at a later point in its history. This is an unusual subject, and Tintoretto may have painted it at the request of his patron, perhaps the renowned scholar Tommaso Rangone, who adopted this fable as his personal device. The combination of stars and flowers was entirely appropriate because Rangone, a scholar and teacher of medicine, was interested both in astrology and in the healing properties of plants.

30. Detail of 29.

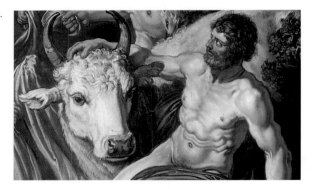

J UPITER, supreme ruler of the gods, was a tireless seducer. He transformed himself into all manner of guises in order to trap his unsuspecting victims: on different occasions, he turned himself into a swan, a bull, a shower of gold, and even his victim's husband. The compelling ingredients of these entertaining stories – love, jealousy, deceit, intrigue and scandal – made them a popular theme for artists and patrons alike. In *Juno discovering Jupiter with Io* [32], the seventeenth-century Dutch artist Pieter Lastman showed the king of the gods at his most undignified: naked and red-faced, having been caught *in flagrante* by Juno. Lastman focused on the emotional response of Jupiter and Juno giving this scene the immediacy of a real domestic drama. Jupiter tried to conceal his indiscretion by transforming his lover, Io, into a white

32. Pieter Lastman, *Juno discovering Jupiter with Io*, 1618, 54.3 × 77.8 cm.

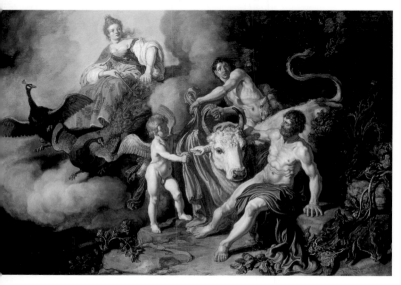

42

heifer, but the suspicious Juno placed the heifer under the watchful guard of the 100-eyed giant, Argus. Jupiter sent his messenger Mercury to rescue Io, and in the process, Argus was killed. Juno gathered his eyes and in an act of remembrance, set them into the tail of her peacock. And that, according to this myth, is how the peacock's tail acquired its distinctive pattern.

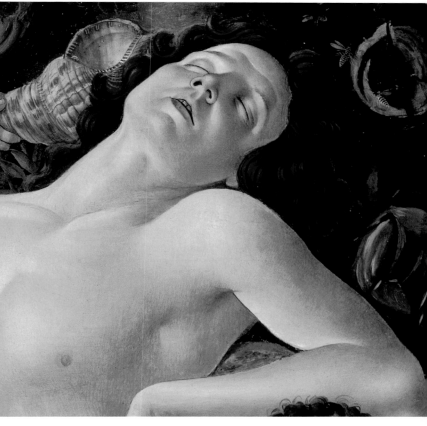

MARS, god of war, was the son of Jupiter and Juno. Aggressive and violent, he was unpopular with all the gods apart from Venus, who became his lover. Mars usually wears a helmet and breastplate, and is depicted as a strong man, sometimes young and sometimes old. In Botticelli's *Venus and Mars* [33], we see nothing of the usual bellicose image. Disarmed, he lies in a deep sleep, exhausted and mellowed by love.

33. Detail of 6.

MERCURY, messenger of the gods, was a son of Jupiter, and usually plays a supporting role, running errands for the gods and ferrying them from place to place. His attributes are his winged hat and boots, which endowed him with speed, and his caduceus, a magical wand entwined with two snakes that ensured him a clear route on his journeys. In Correggio's *Venus with Mercury and Cupid* [34] Mercury takes centre stage as he teaches the infant Cupid, while Venus looks on. This mysterious painting does not depict a specific story (Mercury and Cupid were not related and Venus did not have wings); instead it conveys an allegorical meaning, which is not fully understood, but is most likely to derive from astrology. This painting was one of several mythological paintings Correggio made for Federico II Gonzaga, duke of Mantua. Like his cousin Alfonso d'Este, duke of Ferrara, Federico commissioned these paintings to adorn a single room of his palace.

34. Correggio, *Venus with Mercury and Cupid ('The School of Love')*, detail, about 1525, 155.6 × 91.4 cm.

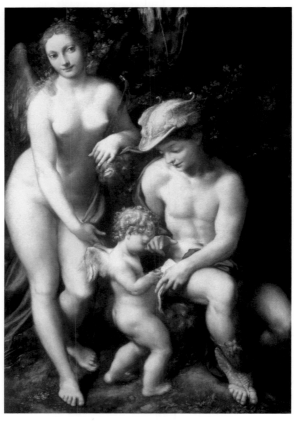

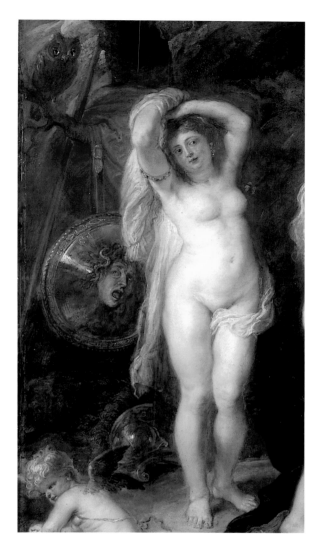

MINERVA, goddess of wisdom, presided over the arts and sciences. She was a daughter of Jupiter, and sprang fully formed and armed from his head. Accordingly, artists usually depicted her wearing a helmet and carrying a shield, as in Rubens's *Peace and War* [17]. She appears again in another work by Rubens, *The Judgement of Paris* [35], where she has shed her armour. Her shield is adorned with the head of the Gorgon Medusa, whom she helped Perseus to kill, and perched on the tree just above it is an owl, a symbol of wisdom.

35. Detail of 53.

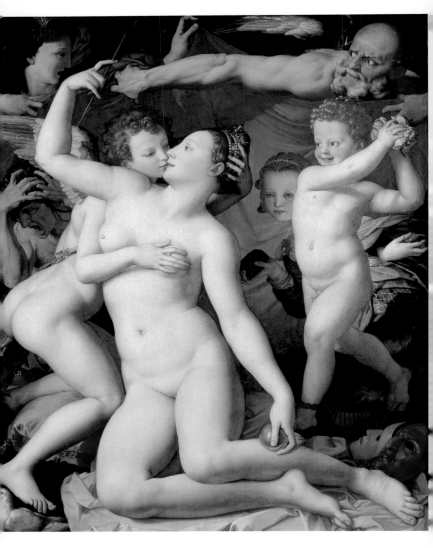

36. Bronzino,
*An Allegory with
Venus and Cupid*,
probably 1540–50,
146.1 × 116.2 cm.

VENUS, the goddess of love and beauty, was the mother of Cupid, the wife of Vulcan and – according to Homer – a daughter of Jupiter. Other sources describe how she was born from the waves of the sea, and this legend gave her one of her attributes, the pearl. Other symbols associated with Venus include the myrtle plant (which is evergreen, just as love is eternal), roses, doves and a golden apple awarded to her by Paris. Several of these are included in *An Allegory with Venus and Cupid* [36], by the fifteenth-century Florentine artist, Bronzino, a puzzling

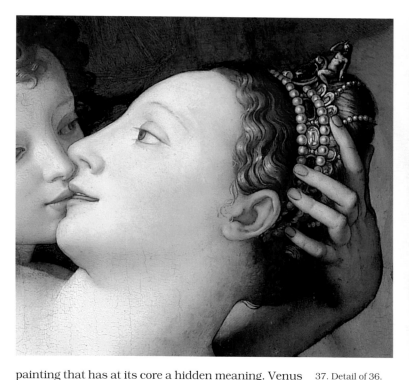

painting that has at its core a hidden meaning. Venus and Cupid are locked in an intimate embrace, and as they kiss, the goddess of love steals her son's arrow, disarming him. The message may be that Beauty restrains Passion, and in doing so, rids the world of the pitfalls and painful consequences of love. A colourful cast of characters illustrates what these are: a playful child representing the fool, or Folly, is poised to scatter a handful of rose petals. He is so caught up in the fun of the moment that he fails to notice the painful thorn piercing his foot. Behind him is Deceit, a young girl whose pretty dress conceals the body of a monster. At the top Time, identified by his wings and hourglass, pulls back a piece of fabric to reveal the mask-like face of Oblivion, who has no brain in which to store her memories. Last of all, the figure beneath Oblivion, grasps his head in agony, embodying the anguished emotions caused by love, perhaps jealousy. This painting was probably made as a gift from Duke Cosimo de' Medici of Florence to King Francis I of France at whose court Bronzino's sophisticated mythological puzzle would have both entertained and delighted.

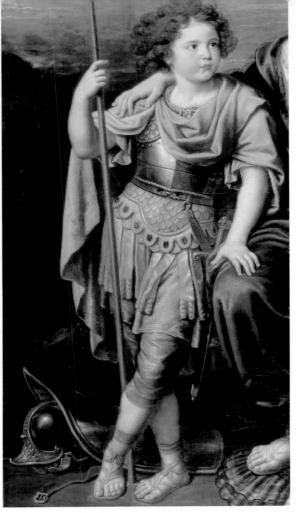

38. Detail of 18.

VULCAN, the blacksmith of the gods, lived inside the crater of a volcano where he forged arms and armour. The son of Juno and Jupiter, Vulcan was so ugly at birth that his mother threw him down from Mount Olympus, leaving him crippled. Later in life, he enjoyed better fortune when Jupiter gave him the beautiful Venus as his wife. However, Venus was constantly unfaithful and, in revenge, Vulcan made an iron net that was so fine it was invisible. He waited until Mars and Venus were in bed together, then trapped them in his net, and invited all the gods to come and witness their shame. Although Vulcan is not represented in the National Gallery's collection, there are plenty of depictions of his handiwork [38].

D APHNE was a wood nymph, whose story has at its core a mismatched love. Cupid, in a troublesome mood, fired a golden arrow at Apollo, which made him fall in love with Daphne, and at the same time, shot Daphne with a lead arrow, which banished all feelings of love. The Florentine artist Antonio del Pollaiuolo shows what happened next [39]. The amorous Apollo pursued Daphne until she was too weak to go any further. Exhausted, she prayed to her father, the river god Peneus, for help,

39. Antonio del Pollaiuolo, *Apollo and Daphne*, probably 1470–80, 29.5 × 20 cm.

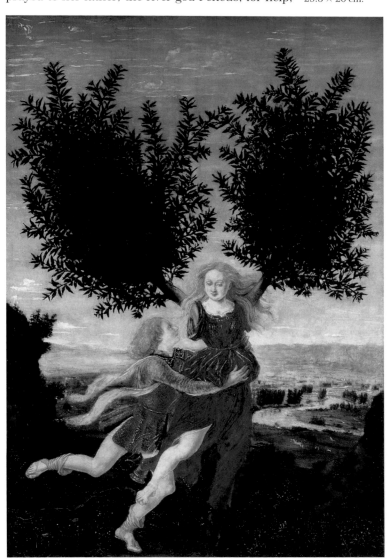

and was magically turned into a tree, a transformation we see taking place in this painting. The couple are clothed in contemporary fashions and appear against the backdrop of the Arno valley, which for fifteenth-century viewers would have increased the resonance of this ancient myth. Like the *cassone* chests and *spalliera* panels discussed earlier in this book, this painting was originally made to adorn a piece of furniture.

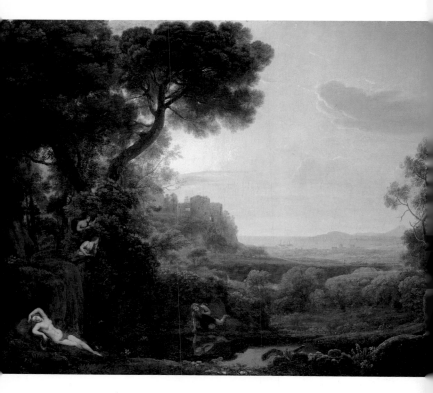

40. Claude, *Landscape with Narcissus and Echo*, 1644, 94.6 × 118cm.

41. Detail of 40.

ECHO. The myth of Echo and Narcissus tells of the devastating results of unrequited love [40]. Echo liked to gossip and would divert Juno with her idle chatter, while Jupiter cavorted with other nymphs. When Juno learned of this ploy, she condemned Echo to being only able to repeat the last words spoken to her. The muted nymph eventually fell in love with a handsome youth called Narcissus, but when he spoke to her, all she could do was repeat his words. He eventually spurned her, leaving the heartbroken Echo to fade away until all that remained

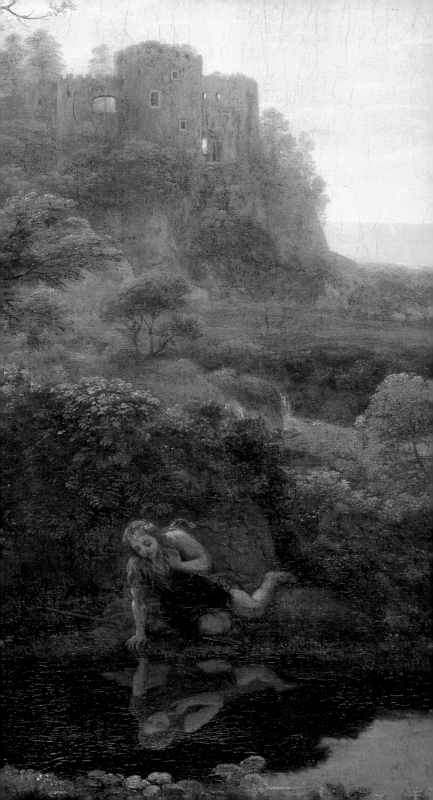

of her was her voice. She prayed to Nemesis, goddess of revenge, and Narcissus was condemned to fall in love with his own image. Two paintings at the National Gallery depict him looking longingly at his own reflection: one by a sixteenth-century follower of

42. Follower of Leonardo da Vinci, *Narcissus*, about 1490–9, 23.2 × 26.4 cm.

Leonardo da Vinci [42], and the other by the seventeenth-century landscape painter Claude [40]. Each time Narcissus tried to touch the water, the handsome reflection disappeared into the ripples, and the miserable Narcissus faded away to nothing, until only a flower remained in his place: a white and yellow bloom that still bears his name today. Claude included a group of narcissi growing at the side of the pool, a hint of the tragic outcome of Echo and Narcissus' tale [43]. As a landscape painter, Claude was as interested in the setting of this scene – the shadowy forest glade in the foreground and the sun-drenched view beyond – as he was in the characters.

43. Detail of 40.

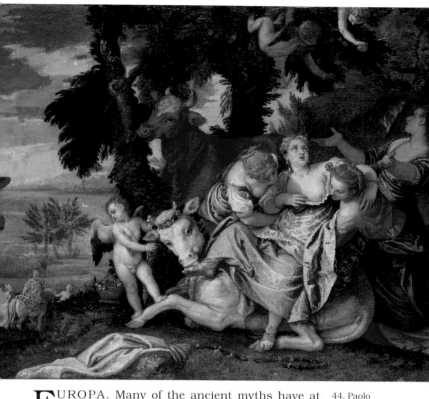

EUROPA. Many of the ancient myths have at their core the theme of unreciprocated love. However, Jupiter ensured his desires were always sated, either through deception or force. This was the fate suffered by the young princess Europa, whose unfortunate tale is depicted by the sixteenth-century Venetian artist, Paolo Veronese [44]. When Europa caught Jupiter's eye, he disguised himself as a bull, and approached her as she played by the seashore. Taken in by the beast's apparent gentleness, she put a garland of flowers around its horns, and sat on its back. Jupiter seized the moment, and carried her out to sea, all the way to the island of Crete where he shed his disguise, and raped her. This is a smaller version of a much larger painting Veronese made of this same subject, now in the Doge's Palace in Venice.

44. Paolo Veronese, *The Rape of Europa*, about 1570, 59.4 × 69.9 cm.

EURYDICE. Wife of the Thracian poet, Orpheus who was known for his ability to charm wild beasts with the sweet music of his lyre. Her tragic tale is illustrated in *The Death of Eurydice* [45] by the

French artist Niccolò dell'Abate. She appears twice; firstly unwittingly treading on a poisonous snake as she flees from the advances of the shepherd Aristaeus; and secondly lying dead on the ground. The next part of the story continues elsewhere in the painting. In the distant right, Aristaeus appears again, in conversation with his mother from whom he sought advice after his bees mysteriously died. She tells him that this is punishment for pursuing Eurydice. In the left background Orpheus, grief-

45. Niccolò dell'Abate, *The Death of Eurydice*, 1552–71, 189.2 × 237.5 cm.

stricken at his wife's death, plays mournfully to a group of attentive animals. Unwilling to accept his devastating loss, he descended to the Underworld in search of Eurydice. Once there, he used his sweet music to persuade Pluto, god of the Underworld, to allow Eurydice to return the land of the living. Pluto told Orpheus that if he played his lyre, Eurydice would follow its familiar sound, on condition that Orpheus did not look back until he returned to earth. As they moved through the darkness, Orpheus, eager

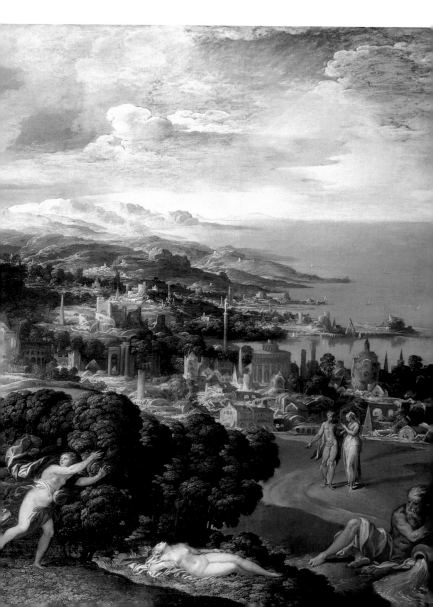

to see his wife, simply could not stop himself from glancing back; as he did so, Eurydice immediately disappeared forever into the depths of the Underworld. Having lost her for a second time Orpheus was inconsolable with grief. Although Niccolò dell'Abate did not depict this final tragic outcome, he showed the various episodes that led up to it unfolding gradually against the backdrop of this vast fantastical landscape.

PSYCHE. This story was written by Lucius Apuleius (born about AD 23), and possibly based on an earlier myth. Psyche, a young princess, was so

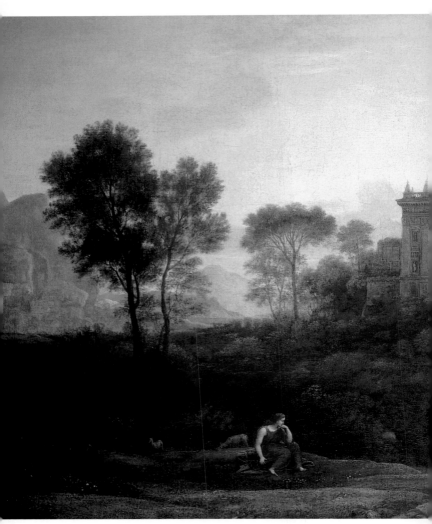

beautiful that the jealous Venus plotted against her. She sent Cupid to cause Psyche heartache and misery with his arrows, but instead Cupid fell in love with her himself, and swept her off to a magical palace. This is 'The Enchanted Castle' [46] depicted by the seventeenth-century French artist, Claude. When Psyche entered, she found a magnificent interior with gold columns, jewelled floors, and invisible servants to attend her every need. Cupid, however, remained hidden, visiting only under the cover of darkness; his one condition to Psyche was that his identity should be a secret.

46. Claude, *Landscape with Psyche outside the Palace of Cupid ('The Enchanted Castle')*, 1664, 87.1 × 151.3 cm.

In *Psyche showing her Sisters her Gifts from Cupid* [48] by Jean-Honoré Fragonard, Cupid is nowhere to be seen, but the artist suggested his presence with

47. Detail of 48.

the quiver of arrows on the floor [47] and in the arm of Psyche's chair. As Psyche welcomes her sisters to her new home, Eris, goddess of Strife hovers above, filling the sisters with envy. The story goes on to tell how they suggested to Psyche that her hidden lover might be a beast or a monster. So one night she took a lantern to bed, and glimpsed Cupid while he slept. Her fears were quelled, but it was too late: a drop of hot oil fell from the lantern, and woke Cupid. Enraged that his one rule has been broken, he departed, the castle and its riches disappearing with him. This story was well known in eighteenth-century France, as it featured in the romantic tale *Les Amours de Psyché et Cupidon* by Jean La Fontaine, which Fragonard probably used as his source.

48. Jean-Honoré Fragonard, *Psyche showing her Sisters her Gifts from Cupid*, 1753, 168.3 × 192.4 cm.

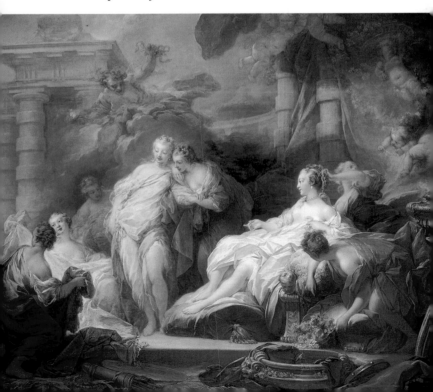

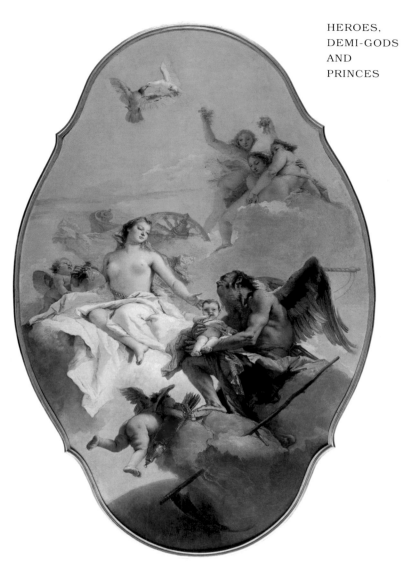

ᴀENEAS was a Trojan hero and demi-god, the
son of a shepherd called Anchises and Venus,
goddess of love, who was destined to live as a mortal
on earth. In *An Allegory with Venus and Time* [49] by
the eighteenth-century Venetian artist, Giovanni
Battista Tiepolo, the infant Aeneas occupies the
centre of the canvas. Venus is passing him down
from the domain of the gods into the hands of Old
Father Time, who will take him to live a mortal exis-
tence on earth. Above, the Three Graces scatter rose

49. Giovanni
Battista Tiepolo,
*An Allegory with
Venus and Time*,
about 1754–8,
292 × 190.4 cm.

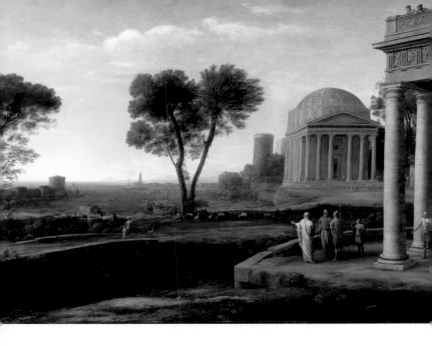

50. Claude,
Landscape with Aeneas at Delos,
1672,
99.6 × 134.3 cm.

petals, while below, Cupid clambers onto a cloud. This vertiginous setting was perfectly suited for the intended location of this painting: the ceiling of the Contarini Palace in Venice. The Contarini family may have commissioned the work to celebrate the birth of a new heir and their choice of subject was perhaps influenced by the fact that the family were said to have claimed to be descendants of Aeneas.

Aeneas left the burning city of Troy at the end of the Trojan War, and set off on a long journey in quest of a new homeland. Claude's *Landscape with Aeneas at Delos* [50] depicts an episode from this epic journey. In it, Aeneas, his father and son have landed on Delos, an island sacred to Apollo, and are welcomed by its king, Anius. He shows them the important landmarks of his island: the hybrid palm and olive tree to which Latona clung as she gave birth to Apollo and Diana, and the temple of Apollo, of which he was the priest. As Aeneas made his offerings to the sun god, he was told to seek his new home in a place that was known to his ancestors, which he first took to mean Crete and then understood to be Italy. Aeneas' final destination is suggested by the architecture of the temple of Apollo, on the right. It is based on the Pantheon, which still stands in Rome today and provides a visual clue to Aeneas' final destination. This scene is rarely depicted

in art, and was the first in a series of six paintings of episodes from the legend of Aeneas that Claude painted in the last ten years of his career.

Dido receiving Aeneas and Cupid disguised as Ascanius, by the eighteenth-century Neapolitan artist Francesco Solimena [51], depicts a later episode of Aeneas' epic journey. In this story – which has also provided a rich source for music and drama – Aeneas arrives in the kingdom of Queen Dido, an ally of Venus' arch rival Juno. Venus, fearing for her son's safety, sends Cupid disguised as Aeneas' son, to make Dido fall in love with her visitor, and their subsequent passionate love affair banishes all thoughts of Aeneas' quest from his mind. Jupiter despatches his messenger, Mercury, to prompt Aeneas to fulfil his destiny, and he quickly departs, abandoning his lover. Heartbroken, the Queen orders the building of a large pyre, stabs herself with a sword that Aeneas had presented to her, and falls into the flames.

In this flamboyant, theatrical painting, Solimena depicts Cupid as his usual winged and chubby self, revealing Venus' ploy to the viewer. He also revels in other details: Dido's exotic turban, the richly coloured costumes, and the gleaming hilt of Aeneas' sword, which perhaps alludes to Dido's tragic death.

51. Francesco Solimena, *Dido receiving Aeneas and Cupid disguised as Ascanius,* probably 1720s, 207.2 × 310.2 cm.

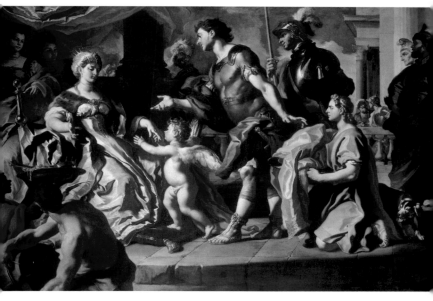

52. Detail of 53.

53. Peter Paul
Rubens,
*The Judgement of
Paris,*
probably 1632–5,
144.8 × 193.7 cm.

PARIS was the son of King Priam of Troy. Before his birth, his mother Hecuba had a prophecy that her child would bring about the destruction of Troy, so she abandoned him on the slopes of Mount Ida where he was found and brought up by shepherds. Paris was later chosen to judge a beauty contest between three goddesses, which came about at a wedding feast to which all the gods and goddesses had been invited apart from one – Eris, the goddess of strife. To avenge this, Eris threw a golden apple from the skies, inscribed with the words 'to the fairest'. Three goddesses considered themselves worthy: Venus, Juno and Minerva, and they were taken

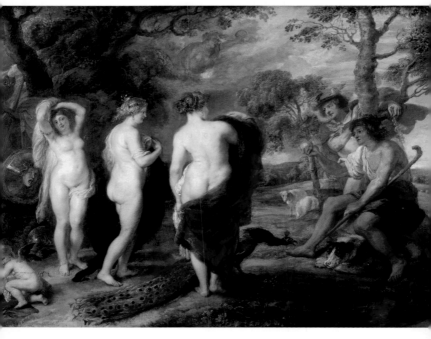

by Mercury to Mount Ida to be judged by Paris. This is the subject of Rubens's *The Judgement of Paris* [53] in which the goddesses can be identified by their attributes: Minerva's owl and armour, Venus' son Cupid, and Juno's peacock. All three goddesses were as beautiful as each other so they each bribed Paris. He was finally swayed by Venus' offer of the love of the most beautiful woman in the world, Helen. However Helen was already married to King Menelaus of Sparta, and when Paris abducted her, war broke out between the Greeks and Trojans – a war that ended in the destruction of Troy, fulfilling the prophecy made at Paris' birth. Rubens hinted at this unhappy outcome with the flaming figure of Alecto, Fury of War, who casts her evil shadow across the sky [52]. During his long career, Rubens painted several versions of *The Judgement of Paris*, a subject that may have appealed as it gave him the opportunity to paint three female nudes, each from a different angle.

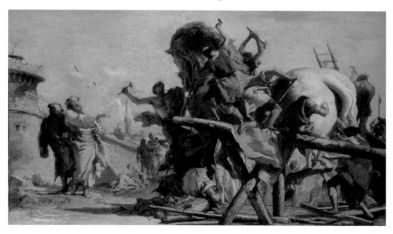

ULYSSES, the Greek hero (Odysseus in Greek), is one of the principal figures of the Trojan War. Known for his shrewdness, he devised a cunning scheme that brought an end to the Trojan War. This is the subject of two paintings by the eighteenth-century Venetian artist, Giovanni Domenico Tiepolo. In the first [54], Ulysses oversees the construction of a gigantic wooden horse, which is inscribed with a dedication to Minerva. The horse was filled with troops and left outside the gates of Troy while the other Greek soldiers pretended to sail away. As planned, the Trojans emerged from their city to inspect

54. Giovanni Domenico Tiepolo, *The Building of the Trojan Horse*, about 1760, 38.8 3 66.7 cm.

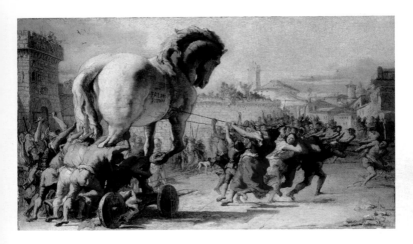

55. Giovanni Domenico Tiepolo, *The Procession of the Trojan Horse into Troy*, about 1760, 38.8 × 66.7 cm.

the horse, and when they saw the dedication to Minerva, they pulled the spectacular beast into the city for fear of offending the goddess [55]. That night, the hidden soldiers crept out, opened the city gates, and let in the Greek troops waiting nearby. They sacked the city, and in doing so, brought the war to an end.

Ulysses' adventures did not end there as more perils awaited him on his journey home. One of these was his encounter with one of the Cyclopes, a one-eyed giant, Polyphemus, the subject of *Ulysses deriding Polyphemus* by J.M.W.Turner [56]. Ulysses and his men had cast anchor at the island depicted on the left, where the fearsome Polyphemus captured them. In order to escape Ulysses encouraged Polyphemus to drink wine, and once he fell into a drunken slumber,

56. Joseph Mallord William Turner, *Ulysses deriding Polyphemus*, 1829, 132.5 × 203 cm.

57. Detail of 56.

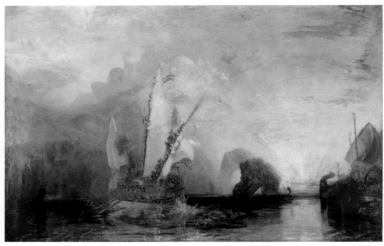

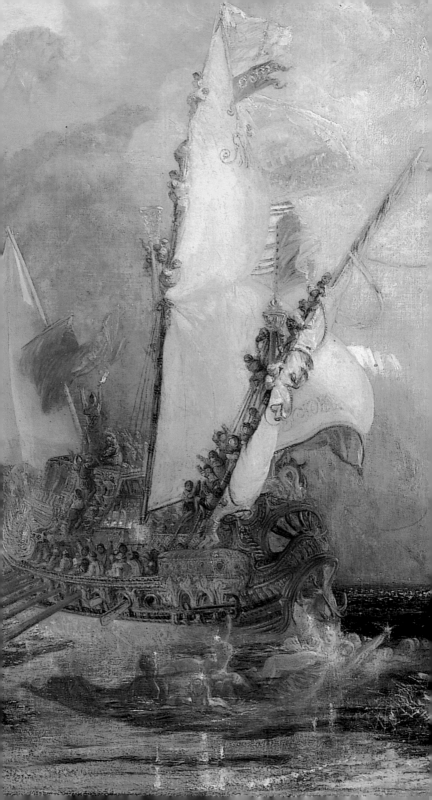

58. Detail of 56.

Ulysses drove a stake into his single eye, blinding him. He and his men then hid in the fleece of Polyphemus' sheep, and as they went out to graze, carried the prisoners out to freedom. In Turner's painting, Polyphemus throws a stone down into the bay to try to prevent their departure, but Ulysses stands victorious on his ship, which is led to safety by a cohort of sea nymphs. Despite the drama of this story, the true subject of Turner's painting is perhaps the glowing light of the morning sun, which he showed being pulled into the sky by the horses of Apollo [58].

59. Pintoricchio, *Penelope with the Suitors*, about 1509, 125.5 × 152 cm.

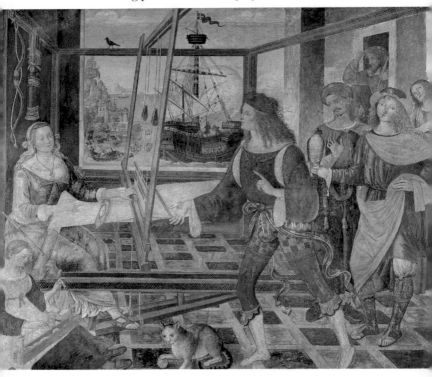

Another painting in the National Gallery depicts some other hazards Ulysses confronted on his epic journey. In the background of *Penelope with the Suitors* [59] by the Italian artist Pintoricchio, we find the dreaded Sirens and the sorceress Circe. The Sirens, who had the heads of women and the bodies of birds, lived on a rocky island where their beautiful songs lured sailors to their deaths. In this detail [60] Ulysses is tied to the mast, and his sailors block their ears to escape the Sirens' beguiling songs. In another episode, Circe turns Ulysses' men into pigs, but as he was resistant to her spells, she agreed to turn them back into men and free them.

The foreground depicts Ulysses' safe return to Ithaca, where his patient wife Penelope sits at her loom. She had waited ten long years for her husband to return, and invented a ruse to keep all suitors at bay. She said that she would only remarry after finishing the shroud she was weaving for Ulysses' father, but every night she unravelled her day's work, and started afresh the next day. She was eventually found out, and so agreed to marry anyone who could string

60. Details of 59.

67

Ulysses' bow – on the loom behind her, and use it to shoot an arrow through twelve axes. Ulysses returned, disguised as a beggar, and was the only one able to complete Penelope's task. The story ends with Ulysses killing his rivals, and reclaiming both his wife and his palace. This painting was one of many frescoes commissioned by the Sienese ruler Pandolfo Petrucci for Palazzo Magnifico in Siena. Like several other mythological paintings of the Italian Renaissance (the *cassone* and *spalliera* paintings discussed elsewhere in this guide), its subject may have had a moral purpose: Penelope's exemplary patience and fidelity would have been understood as the model behaviour of a good wife.

Centaurs had the body of a horse and the torso and head of a human. They were descended from a union between Ixion, king of the Lapiths and a cloud, which Jupiter had transformed into the form of Juno. Known for their rough and aggressive character, they represent the base level of man's nature. Piero di Cosimo's *The Fight between the Lapiths and the Centaurs* [61] shows the disastrous wedding feast of the Lapith king, Pirithous, and his bride Hippodamia. Pirithous had made the mistake of inviting his distant relatives, the centaurs, and as the celebrations started, they became drunk and rowdy. This painting corresponds closely to Ovid's graphic description of this scene: one centaur tries to carry off the bride [62], while others throw anything they can lay their hands on: goblets, jugs, candlesticks and table legs. The centaurs were eventually banished,

61. Piero di Cosimo, *The Fight between the Lapiths and the Centaurs*, probably 1500–15, 71 × 260 cm.

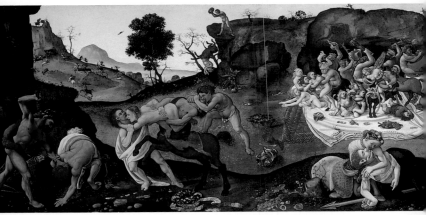

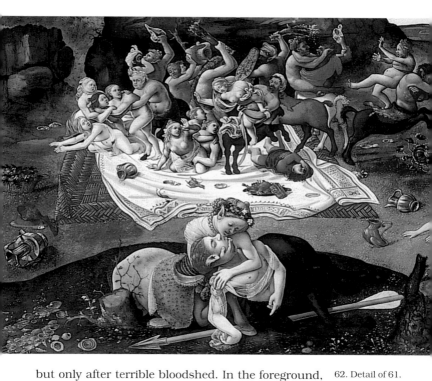

but only after terrible bloodshed. In the foreground, a female centaur cradles the body of her dead lover, Cyllarus [62], a poignant detail proving that these wild creatures also suffered grief. This story was usually understood as symbolising the triumph of civilisation over barbarism, but in the context of this painting, which was made for a domestic setting, its sensational details would also have been a source of great amusement and entertainment.

62. Detail of 61.

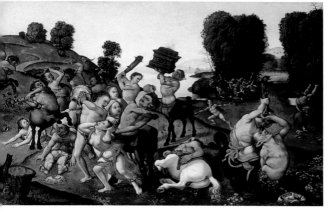

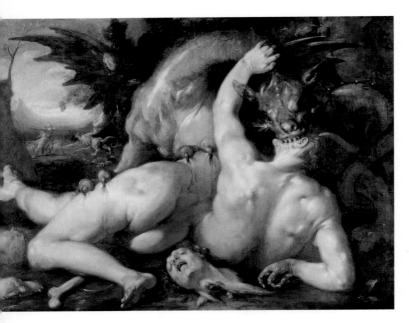

63. Cornelis van Haarlem, *Two Followers of Cadmus devoured by a Dragon*, 1588, 148.5 × 195.5 cm.

DRAGONS. The beast in *Two Followers of Cadmus devoured by a Dragon* by the Netherlandish artist Cornelis van Haarlem must be one of the most terrifying ever painted [63]. Combining the features of a bird, reptile and mammal, it sinks its hungry teeth and claws into the fleshy bodies of two followers of Cadmus, the legendary founder of Thebes. Cadmus had been advised by the oracle of Delphi to follow a heifer, and to found his city on the spot where the weary beast sat down. When he finally arrived at this place, Cadmus sent his men to fetch water and in their search for a spring, they entered a cave unaware that it was home to a fierce dragon. It devoured them,

64. Detail of 63.

but Cadmus in turn slew the beast [64] and afterwards buried its teeth in the ground, where they magically transformed into soldiers, who helped him found the city of Thebes.

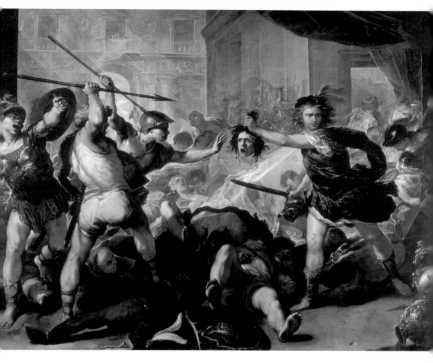

GORGONS. These three fearsome sisters had snakes for hair and their fatal gaze turned anyone who looked at them into stone. The most famous of the three was Medusa, the only mortal among them. She met her death at the hand of the hero and demi-god Perseus, who was aided by Minerva and Mercury. Mercury lent him his winged boots, which ensured him a speedy escape and Minerva lent him her shield, the shining surface of which he used to look at Medusa's reflection, thereby avoiding being turned into stone. In gratitude to Minerva, Perseus gave her the gorgon's head, which she set into her shield [35]. In *Perseus turning Phineas and his Followers into Stone* [65] by the seventeenth-century Neapolitan artist, Luca Giordano, Perseus uses Medusa's head as a weapon, while carefully averting his own gaze. The painting depicts his wedding to the beautiful Andromeda, which was interrupted by

65. Luca Giordano, *Perseus turning Phineas and his Followers to Stone*, early 1680s, 285 × 366 cm.

Phineas, who had also been promised her hand in marriage. Giordano chose to depict the climactic moment: as Phineas and his men advance towards Perseus, he holds up the gorgon's head, which stops them in their tracks as they turn into stone.

HARPIES were terrifying creatures with sallow female faces, winged bird-like bodies, and sharp claws, which they used to steal food. In *The Sons of Boreas pursuing the Harpies* [66], Paolo Fiammingo, a Flemish artist who worked in Italy, gave them the bodies of lizards. This painting depicts the story of the blind Thracian king Phineus who was plagued by the harpies. As soon as food was set down in front of him, they would either defile it with their rancid breath or steal it for themselves. The winged men banishing the fearful harpies are the sons of Boreas, god of the wind, who came to Phineus' rescue.

66. Paolo Fiammingo, *The Sons of Boreas pursuing the Harpies*, 1592–6, 184.8 3 205.1 cm.

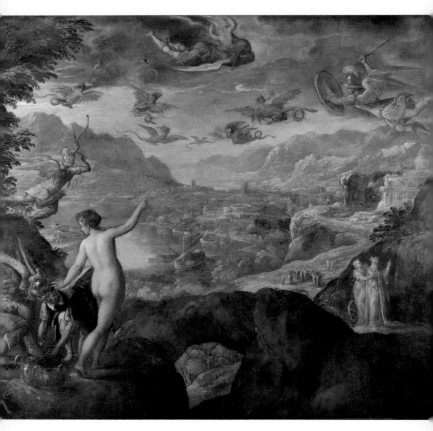

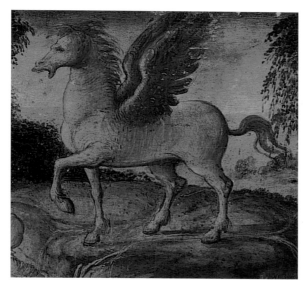

67. Detail of 68.

PEGASUS was the elegant winged horse born from the severed head of Medusa, who went on to help Perseus rescue Andromeda, his future wife. As well as performing such heroic acts, he was also associated with the Muses, the goddesses of creative and intellectual inspiration who governed music, art, history, poetry, dance and astronomy. In *Pegasus and the Muses* attributed to the sixteenth-century Italian artist Girolamo Romanino [68], Pegasus stamps his hooves on the ground, thereby creating the spring of Hippocrene, which was sacred to the Muses.

68. Attributed to Gerolamo Romanino, *Pegasus and the Muses*, probably 1546, 38.1 × 115.6 cm.

SATYRS were spirits of the woodlands and fields. With the legs, hooves and horns of a goat, and the face and torso of a man, they represent the animal side of man's nature. They were closely

73

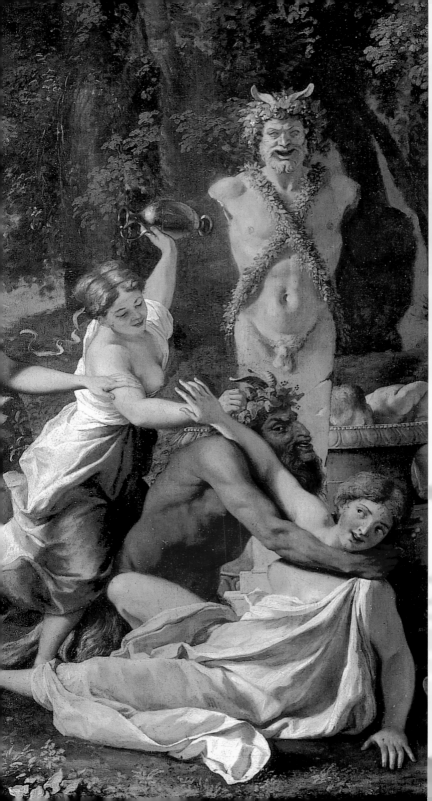

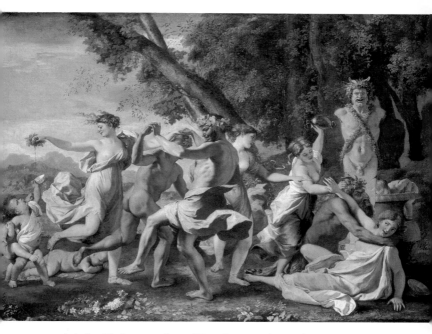

associated with the worship of Bacchus, and are often shown indulging in scenes of revelry, drinking wine and lusting after nymphs, as in *A Bacchanalian Revel before a Term of Pan* [70] by the seventeenth-century French artist, Nicolas Poussin, where the satyr is behaving in typically lecherous fashion. Behind him is a pedestal bearing a bust of Pan, god of the woodlands [69], who is known in Latin as Faunus, and is closely associated with satyrs (or fauns as they are also known). Like Pan satyrs symbolised fertility, and in Medieval and Renaissance art they also came to personify lust and evil.

70. Nicolas Poussin, *A Bacchanalian Revel before a Term of Pan*, 1632–3, 98 × 142.8 cm.

SPHINX. This was another hybrid creature, with the face and breasts of a woman, the body of a lion and the wings of a bird. She guarded the gates of the city of Thebes, and posed a riddle to all those who passed: what has four legs in the morning, two in the afternoon, and three in the evening? Anyone who failed to answer was thrown into a pit. In *Oedipus and the Sphinx* by the nineteenth-century French painter Jean-Auguste-Dominique Ingres [71], Oedipus arrives at the gates of Thebes, and gives the Sphinx the correct answer: a human being has four legs when it crawls in infancy, two legs when it walks as an adult,

69. Detail of 70.

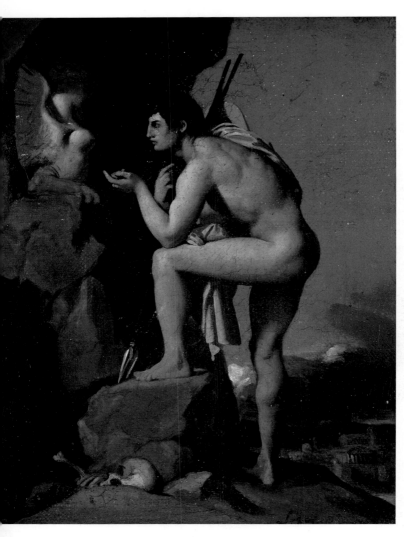

71. Jean-Auguste-
Dominique Ingres,
*Oedipus and the
Sphinx*,
about 1826,
17.5 × 13.7 cm.

and three when it leans on a stick in old age. Shocked
that the riddle had finally been solved, the Sphinx
killed herself. Oedipus received a hero's welcome from
the citizens of Thebes and was given their queen,
Jocasta as his wife. This fulfilled a Delphic prophecy
that Oedipus would kill his father and marry his
mother: unbeknown to him a man he had killed dur-
ing his journey was his father, and Jocasta was
indeed his mother.

CONCLUSION

Although the ancient myths are perhaps less familiar to us nowadays than they were to people in the past, they continue to exert their influence on contemporary artists. *Marsyas* [72], for example, is a vast work by the artist Anish Kapoor, made for the

72. Anish Kapoor, *Marsyas*, 2002, Installation at Tate Modern

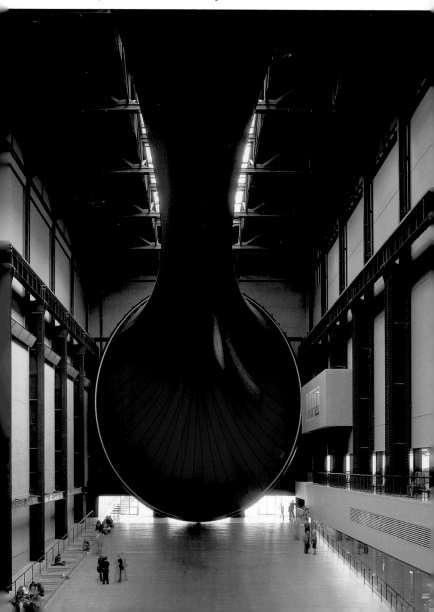

Turbine Hall of Tate Modern in London. Despite being an abstract piece, it was inspired by the mythological character, Marsyas, a satyr who played the flute so well he confidently challenged Apollo to a musical contest. Apollo won the competition and punished Marsyas by flaying him alive; the satyr's blood then turned into the river Meander. Kapoor was not interested in depicting the details of the story, but focused instead on the compelling image of the satyr's blood, embodied in the sculpture's deep red surface. Its curving form evokes the flow of a river, while its vast scale makes it as all encompassing as the sky. This allusion to nature recalls the way myths were understood in the ancient world, that is, as stories that explained natural phenomena by ascribing them human origins – like Narcissus becoming a flower, or Daphne being transforming into a laurel tree. So not only does the tale of Marsyas live on in this sculpture, it also retains something of the meaning it held in earlier times – such is the lasting power of myths.

Just as Orpheus' music captivated animals and birds, classical myths enchanted generations of listeners and readers, and inspired artists to translate the written word into vivid and enthralling works of art. Indeed, as the ancient storytellers gave these stories their own personal rendition, so too have visual artists, past and present, breathing new life into these tales, and making them relevant to their own age.

73. Detail of 45.

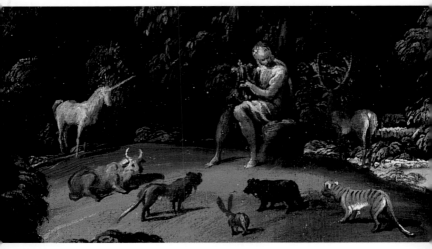

GLOSSARY

LATIN	GREEK
Apollo	Helios
Bacchus	Dionysus
Ceres	Demeter
Cupid	Eros
Diana	Artemis
Faunus	Pan
Hercules	Herakles
Juno	Hera
Jupiter	Zeus
Mars	Ares
Mercury	Hermes
Minerva	Athene, Pallas
Neptune	Poseidon
Pluto	Hades
Saturn	Kronos
Ulysses	Odysseus
Venus	Aphrodite
Vulcan	Hephaestus

FURTHER READING

ORIGINAL SOURCES

Homer, *The Iliad*, trans. E.V. Rieu, London, 2003

Homer, *The Odyssey*, trans. E.V. Rieu, London, 2003

Ovid, *The Metamorphoses*, trans. David Raeburn, London, 2004

Virgil, *The Aeneid*, trans. David West, London, 2003

GENERAL

I. Aghion, C. Barbillon, F. Lissarrague. *Gods and Heroes of Classical Antiquity*, Flammarion Iconographic Guides, Paris, 1996

J. Dunkerton, S. Foister, N. Penny, *Giotto to Dürer: Early Renaissance Painting in the National Gallery*, New Haven and London, 1991

J. Dunkerton, S. Foister, N. Penny, *Dürer to Veronese: Sixteenth-Century Painting in the National Gallery*, New Haven and London, 1999

P. Grimal, S Kershaw, A.R. Maxwell-Hyslop, *Penguin Dictionary of Classical Mythology*, London, 2004

E. Kearns, S. Price, *The Oxford Dictionary of Classical Myth and Religion*, Oxford, 2004